ART BEING

PAUL CUMES

Copyright © 2019 Paul Cumes

Art has no rules.

And Art is Free.

So do what you want.

Don't listen to me!

CONTENTS

ADVICE ON ART .. 1

PAINTING .. 9

ART AND ARTISTS ..13

WHAT IS ART? ..17

ON CRITICISM ..19

ADVICE ON ART

- You don't have to know what you're doing, you just have to know how to go about not knowing what you're doing.

- It is important to put the right kind of pressure on yourself.

- Constantly examine your own insecurities and weaknesses.

- A great way to learn how to paint is to find the very best master you can, study under him or her, and then do the opposite of everything you learned.

- Avoid excessive preconception.

- It's one thing to be a bad artist, but there is nothing worse than a bad, lazy artist.

- Seek spontaneous impressions of the world and see it with fresh eyes every time.

- When you aren't inspired, use your lack of inspiration for inspiration.

- Don't limit your subject matter out of pretense.

- Better to be timeless than to be trendy.

- Rather than trying to paint the right idea, you're better off just making sure it's not the wrong one. Know what you don't like and secretly be your own worst critic.

- View all things as part of a spectrum.

- Look at the great painters and pay attention to their subject matter.

- Be aware of necessary obstacles. You don't have to solve every problem in a painting. Often times a problem is better left off to solve in the next piece.

- Your confidence and work ethic must be as great as your imagination.

- Don't be a bland-scape painter.

- Gimmickry is not good art. Avoid shiny objects, bells and whistles.

- Be spontaneous and impulsive. Don't try to prescribe the course of your art. It'll figure itself out.

- Don't worry about other people's taste or opinions.

- Anyone can make their art detailed and complex. It is more difficult to be simple and beautiful.

- If you can't paint what you want then just keep going until you get something even better.

ART BEING

- Know when to stop painting, but don't be afraid to start again.

- Have an open mind. You will never create something you aren't willing to believe in.

- Explore the process of deconstruction in painting.

- Beware of those that think they know how your art should look.

- Art requires using as many of the senses as possible. At the same time, deprivation of the senses can be a good thing. Goya couldn't hear (but could paint circles around anyone) and many masters (such as Picasso) often painted late at night, in the dark.

- If you are to paint you have to be unable to do anything else.

- Don't be afraid to let go of an idea.

- Learn from the past but look to the future.

- Become who you are. It might take a lifetime.

- Believe in the infinite potential of your art.

- Avoid the art scene. Put your art-making first.

- It's good to take advice (even my advice), but do so with great caution.

- The more you listen to an art teacher, the less you will learn.

- Drawing is the soul of art.

- There is no way.

- Don't let your work look like you are trying too hard, especially if you are.

- Work as quickly as possible.

- The best way to paint something is to paint everything else except that thing.

- Avoid formula painting. Formulas are for scientists.

- It's all personal, but try not to take it personally.

- Have a love of fate.

- Don't worry about theory. That comes later.

- The less someone understands your art the more you should charge them to buy it.

- Beware of people that use "art" to rationalize their bad behavior.

- Do not avoid being humbled but avoid people that take it upon themselves to humble you.

- Your objective is freedom. Slavery will sneak up on you if you're not vigilant.

ART BEING

- Stop painting when the voice in your head telling you to paint is quieter than the voice telling you to stop.

- Know who you are and detach from people that bring you down.

- Let your soul out.

- Feel your way through it.

- Have confidence in your unique imperfection.

- Trust in your self. Don't follow others or try to be like someone else.

- Avoid comfort.

- If you run out of inspiration, use your lack of inspiration for inspiration.

- If anyone ever calls you a legend in your own mind, tell them that you have to start somewhere.

- It's better to be a good artist than to look like a good artist.

- Never sell your soul, but it's ok to consider a few offers.

- If you need to validate your existence, then draw.

- If you still need to validate your existence, then draw a selfie.

- Nulla dies sine linea. "No day without a line".

- Paint while hungry. When we are hungry we see colors better and our intuitive skills become sharper.

- Pay attention to your dreams at night. The great artists of history will visit you.

- Do not concern yourself with perfection. Style comes from imperfection.

- Don't worry about enlightenment as an artist. You're not a spiritual guru. Not being enlightened is part of the deal.

- If you're going to dedicate your life to your art, do it no matter what the cost.

- You don't need, nor should you seek, validation from your family for your artwork.

- Make every piece original.

- Avoid redundancy within the painting.

- Know when to transcend your ego, and when to harness it.

- Never be afraid to sacrifice material wealth for your art.

- Appreciate all the beauty of creation.

- Avoid those who mock your enthusiasm.

- You must develop a thick skin. Showing your art is the best way to do this. Criticism should glide off of you like water off a duck's back.

- Don't refrain from showing your art online (because you are worried about people stealing it). Better to have it stolen than not to show it.

- Don't overprice your work, but more importantly, do not underprice it!

PAINTING

- Painting is a form of problem solving.

- All painting is biographical.

- Painting is an abbreviation, but also an enhancement, of nature.

- Painting things is a way of decoding the natural world.

- A painting is like a person, be suspicious of one that doesn't have any mistakes.

- In painting there is no difference between knowing and doing.

- The language of painting is pigment.

- Paintings are like people. Sometimes it takes a while to understand them, sometimes you understand them right away, and sometimes you never understand them at all.

- Painting is primarily a temperamental thing.

- Painting, like evolution and cell biology, is about differentiation.

- Painting is like magic, but real; for only in painting can one learn all the secret tricks and still not know how it happened.

- Painting expresses the truth and hides the lies.

- Special effects are for the movies, not for painting.

- Great painting is the recognition of beauty.

- In a great painting, the whole is greater than the sum of its parts.

- A painting is like a dream where you only remember the important parts.

- A great painting is neither over-painted nor under-painted.

- Painting is upstream from all other visual arts (like illustrating, for example). It's the most primal visual art.

- Great paintings get better over time and bad ones get worse.

- In good painting, no two times are the same.

- Painting isn't passé.

- Painting takes immense courage. Especially in public.

Art Being

- Painting is a form of prayer. You can ask the ancestors (or the creator him/herself) for help if you need to.

- The painting already exists somewhere unseen before it is painted.

ART AND ARTISTS

- Fear of insignificance is a great motivator for the artist.

- Your artistic greatness will be unique.

- The temperament of a painter requires that one must be in touch with one's feelings as well as be out of touch with one's feelings.

- Moods help the artist make use of his feelings. Take advantage of them.

- Your individual art spirit is the ultimate currency.

- The best color theory is an intuitive one.

- The pendulum of art will swing your way. No need to follow trends.

- Simplification in art takes intelligence.

- Naivety in art is not a bad trait.

- Beauty is the center of art.

- Artists understand that lots of things we don't believe in are more real than we could ever know.

- Science can't explain the imagination and I don't see it happening any time soon.

- Dark art is bad when it is made for the sake of being dark and good when it just happens to be dark.

- As an artist you will inevitably have great despair, but it will pass.

- Almost all education in art is self-education.

- Images are eked out of the imagination in the same way a sculptor chips away at stone.

- Art is pulled from the subconscious like a fisherman pulls a fish out of the ocean.

- The strongest arts are the martial arts. The weakest are the conceptual arts. The tastiest are the culinary arts.

- You draw therefore you are.

- Many want to be an artist but few want to take the time to draw.

- Being an artist is like climbing Mt. Everest, it isn't over until you climb back down again.

- The creative spirit is a bursting rhythm.

- There is no such thing as a mistake in art. Unless you drop a wet painting face down on the floor, I suppose.

Art Being

- Life is a painting that has already been painted and I am but a dribble of oil waiting to dry.

- Your nonsense makes more sense than you think.

- No one knows what anything looks like.

- Exactitude is not truth, but inaccuracy is not a virtue.

- If you're young and draw every day and cannot figure out what to do with your life, congratulations, you're an artist.

- The great thing about being an artist is that you don't have a mid-life crisis. In fact, your whole life is one big crisis.

- Stylistic changes are a blessing, not a curse. Although it might seem the opposite, it is a sign of individuality and greater identity of self.

- I repeat, great art is not repeatable.

WHAT IS ART?

- Art requires inspiration. No matter what anyone says.

- Art is a leap of faith.

- Art, like life, is a tightly woven illusion.

- Art helps reveal the non-physical reality of the universe.

- Art is an obsession with beauty.

- Art reveals the distortions of reality.

- Art shows you what you don't know.

- Art is not ordinary.

- Art is profound even when ridiculous.

- Art is the materialization of spirit.

- Art asks questions, it doesn't answer them.

- Art is more about what you leave out than what you put in.

ON CRITICISM

- Only take criticism from artists you respect.

- It can be good to hear what other artists have to say in an open art critique where people focus on the formal qualities of the work. This helps the art student develop an open mind and a thick skin.

- Seek out the criticism that matters to you and reject the criticism that doesn't.

- Most critics are like hyenas, they only show up after the lion has made its kill.

- It is easier to be a critic than an artist.

- If critics really knew what great art was then they would be great artists.

- Most criticism of art does nothing more than reveal how little the critic knows about art.

- History has many great artists, great musicians, great writers and actors, but can anyone remember any of the critics?

www.ingramcontent.com/pod-product-compliance
Lightning Source LLC
Chambersburg PA
CBHW070846220526
45466CB00002B/904